Chalk in Hand
The Draw and Tell Book

by Phyllis Noe Pflomm

1986

The Scarecrow Press, Inc., Metuchen, N.J., and London

Library of Congress Cataloging-in-Publication Data

Pflomm, Phyllis Noe, 1925–
 Chalk in hand.

 1. Storytelling. 2. Oral interpretation.
3. Blackboard drawing. 4. Libraries, Children's––
Activity programs. I. Title.
Z718.3.P47 1986 027.62'51 86-15480

ISBN: 978-0-8108-1921-4

ACKNOWLEDGMENTS

I would like to thank

•The children's librarians of the Dayton and Montgomery County Public Library who helped me test the stories and poems in this book;

•Charlotte Leonard, retired Coordinator of Children's Services (DMCPL) who encouraged me in my project and suggested that I submit the manuscript to Scarecrow Press;

•And especially the many children who listened and responded.

Dedicated to my mother,
Margaret Noe, and in memory
of my father, Richard Noe,
who drew and told stories.

CONTENTS

Holiday Poems

INTRODUCTION

This book is for anyone who tells stories--parents, teachers, and especially children's librarians for whom story telling is a way of life.

In my work for the Dayton and Montgomery County Public Library I have discovered that a sure way to get the complete attention of children of all ages is to turn to the chalkboard. Perhaps because children themselves enjoy drawing, they are intrigued to see something visual develop as a story unfolds.

All of the stories and poems in this book have been tested. They have been used in library story hours and in visits to schools where teachers have happily shared their chalkboards.

While several of the stories and also the six poems using basic shapes are intended for the Pre-K age group, most of the pieces are suitable for older children as well. The wording (as well as the names of the characters) can be changed to suit the audience.

Writing this book has been a challenge which I have enjoyed. More gratifying has been testing the pieces and having the children respond. I hope that those who use this book will enjoy drawing while telling as much as I do.

Phyllis Noe Pflomm

HINTS FOR THE STORYTELLER

KEEP THE FINISHED DRAWING IN MIND when you begin so that it will be well placed on the chalkboard. Having to stretch or stoop, or worse yet, running out of drawing space would ruin the presentation.

DRAW QUICKLY. Being overly precise interferes with the telling. The children will not be critical of the result, so a carefree approach is best.

THE STORIES: Remember the drawing steps rather than the exact wording. You can make the stories longer or shorter depending on the age of the listener.

THE POEMS: The exact wording is necessary, but most of the poems are short enough to be easily memorized. It is better to read from a palmed index card than to go blank in the middle of the presentation. The children will be concentrating on what you're drawing anyway.

ENJOY YOURSELF. If you are having fun, the children will respond accordingly.

When it's time to hear stories, I put my chair (or cushion) right here,

and I ask you to sit in a little circle like this so that you can see the pictures in the books.

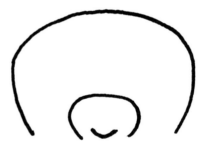

Sometimes there are too many of you to sit in a little circle, so there might be a big one like this.

And of course our circles are not always perfectly round. Some of you might be here....or there.

There may be teachers with you, so they sit in back here.... and here.

And sometimes your mothers or fathers are along, and they sit on the sides there....and there.

Now I am going to sit down right here.

So let's all of us stretch up tall and settle down like this.

And look what we have. All we need is one paw here....
and another one there. Our teddy bear is holding up a
picture book, because it's Story Time. Today we're going
to have _____ . (Fill in "Fairy Tales" or
"Bear Stories" or whatever the theme may be. You can
print this on the open pages of the book that the bear
is holding.)

3

THE STORY TIME BALLOON

Outside today I see the sun
 As bright as it can be,

And down below, a gondola's
 Awaiting you and me.

Come help me with these cables please,
 And climb aboard, for soon

We'll fly away quite happily
 In our Story Time Balloon.

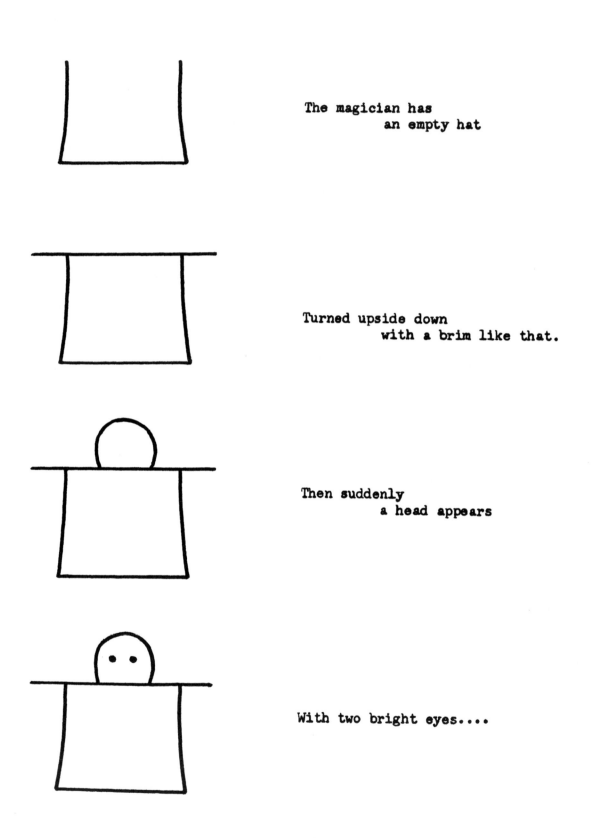

The magician has
 an empty hat

Turned upside down
 with a brim like that.

Then suddenly
 a head appears

With two bright eyes....

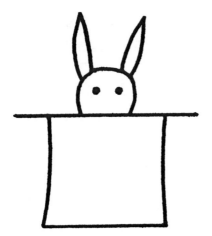

....and two long ears

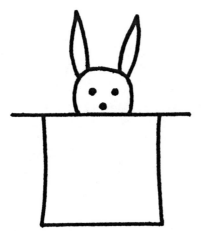

And a small round nose....

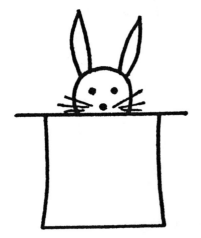

....and whiskers too
And magic stories
 just for you.

(Depending on the theme of the story hour, other
words can be substituted for the word magic in
the last line, such as: rabbit, funny, animal,
lots of, etc.)

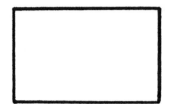

It was a rainy day. Lois
looked out the window, and
this is what she saw.....
Nothing! It was raining
that hard.

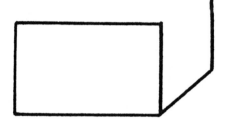

Then she remembered something,
in fact, something just right
for a rainy day. She climbed
a steep flight of stairs, up
and up like this....to the top
of the house,

and she walked into the
attic.

Lois began to poke around
through piles of old-fashioned
clothes, broken toys, and
chairs with missing legs, the
kind of treasures that are
hidden away in most attics.
Finally she reached a corner
here,

and she found what she had
been looking for, a big dust
covered box.

But it wasn't just a box.
It had handles on the sides
like this....and that....

and metal fastenings here....
and there.....

and last, a lock with a key
in it in the front.....It
was Grandma Elsie's trunk.

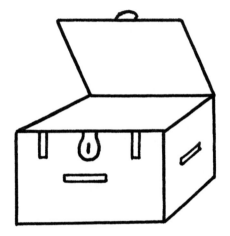

Carefully she turned the
key and lifted the lid,

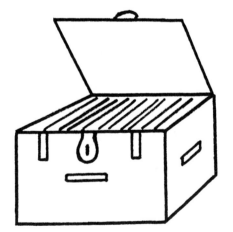

and inside, lined up like
this....were the storybooks
that were Grandma Elsie's
when she was a little girl.
Lois was happy to have found
them, because children today
still love the same books that
Grandma enjoyed when she was
young. Now I am going to tell
you some of these old stories
from Grandma Elsie's trunk.

A TRIP ACROSS THE OCEAN

We're going on a trip across the ocean,
you and me.

We'll travel on a liner. It's a big ship,
you can see,

With many decks piled up like this, so there'll be
room for all
Who want to travel with us to each distant
port of call.

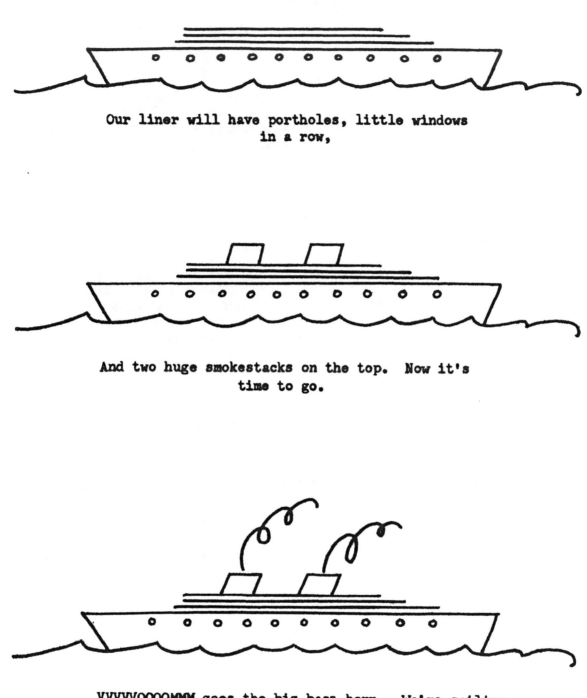

Our liner will have portholes, little windows
in a row,

And two huge smokestacks on the top. Now it's
time to go.

VVVVVOOOOMMM goes the big bass horn. We're sailing,
you and me,
To hear some tales from distant lands
far across the sea.

A GUESSING GAME

(The Bus to Story Land)

 First I'm going to draw a shape like this.....
That's right, it's a square. What could it
be? (Wait for reaction.) Yes, it looks like
a block or a small box.

 Next to the square I'm
drawing another shape.....
That's right, it's a rectangle.
What could this be? Do you
think it looks like two boxes
standing side by side?
(Reaction)

 Here's another rectangle.....
What do you think it is?
Does it look like an oddly
shaped building with a door?
I would like some good guesses.
(Reaction)

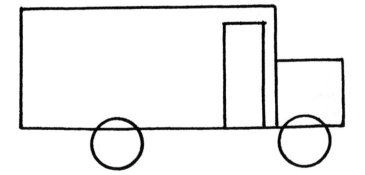 Now I'll draw two circles,
one here....and one there....
It couldn't be a building,
because buildings don't have
wheels. Do I hear some guess-
es? (Reaction) Did someone
say a truck or a van? That's
very good.

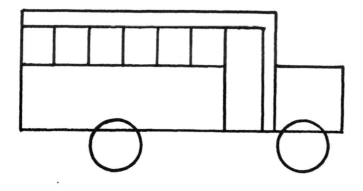

But I'm not finished.
Look.....Did someone tie
a ladder to the side of
our truck? (Reaction)
You're right, it's not a
truck but a bus. Do you
think it's a school bus?
(Reaction)

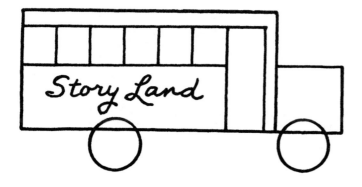

No, it isn't a school
bus. It's a special bus.
I'm going to write some-
thing on the side here.....
S-T-O-R-Y L-A-N-D spells
Story Land. This is the
special bus that is going
to take us there today.

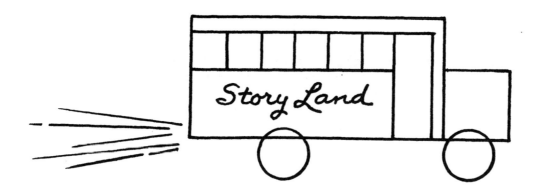

Come on everybody. Let's climb into the bus.
I'll be the driver. VRROOOOOOMMMMM..... I've
started the motor. We're off to Story Land.

13

JASON'S HOUSE

One day Jason found a box that was big enough to
sit in. Here it is.

So he climbed inside. All you can see is the top
of his hat right here.

"This box will be my very own house," said Jason.
But a house needs a window, so he put a window
on this side.

A house should have some front steps too, so he
piled some of his old picture books here for steps,

14

and he glued a paper cup right here for a porch light.

Jason really liked his house, but he was lonely and thought it would be nice to have some neighbors. So he asked his friend Kelly to bring a box, and she put hers right here. It was longer than Jason's, so she put two windows in her house.

Then along came Stacy and Sean bringing their boxes, which they put here and here, and they put some windows in their houses too.

About that time Jason's little brother Dougie woke up from his nap, and he wanted to play too. His mother found him a box which was smaller than the others, but it was big enough for him to sit in, so he put it down here.

All that afternoon Jason and his friends had a great
time playing in their houses. No one was fussing or
fighting, and Jason's mother was really happy that they
were acting like good neighbors. She even had time to
bake cookies. When they were done, she took them out
of the oven and went from house to house like this,

and in front of each one she left a paper
plate with a big cookie on it.

Those cookies smelled so good that they all tumbled out of
their houses (like this) to eat them. Jason turned around
and said, "Look, everyone. Our houses have turned into a
train!" And sure enough he was right. Also, of course, the
cookies were delicious.

NO BUTTERBALL

Charlotte, a little girl who lived on
a farm, had a pet pig named Butterball.
Butterball was a nice little pig with
one very bad habit — she liked to run
away. One morning Charlotte went out-
side and down to the edge of the barn-
yard like this....and began to call her
pet.

"Butterball, Butterball," she
shouted. "It's time for break-
fast." She called and called,
but NO BUTTERBALL. So Charlotte
started down the road like this.

She climbed over a
fence here....and
walked on and climbed
over another fence
here....and walked
some more

until finally she
reached a stone wall
that meant she had
come to the edge of
the farm.

17

There was an old sycamore tree with a swing, but NO BUTTERBALL. Charlotte stopped for a minute to swing like this,

then she circled up through a field where she saw plenty of cows and sheep, but NO BUTTERBALL.

A chicken coop stood over here....so Charlotte looked inside. There were hens and baby chicks and lots of eggs for her to gather later, but NO BUTTERBALL.

Next Charlotte checked the barn. There was an old horse who whinnied at her and two cats that meowed, but NO BUTTERBALL.

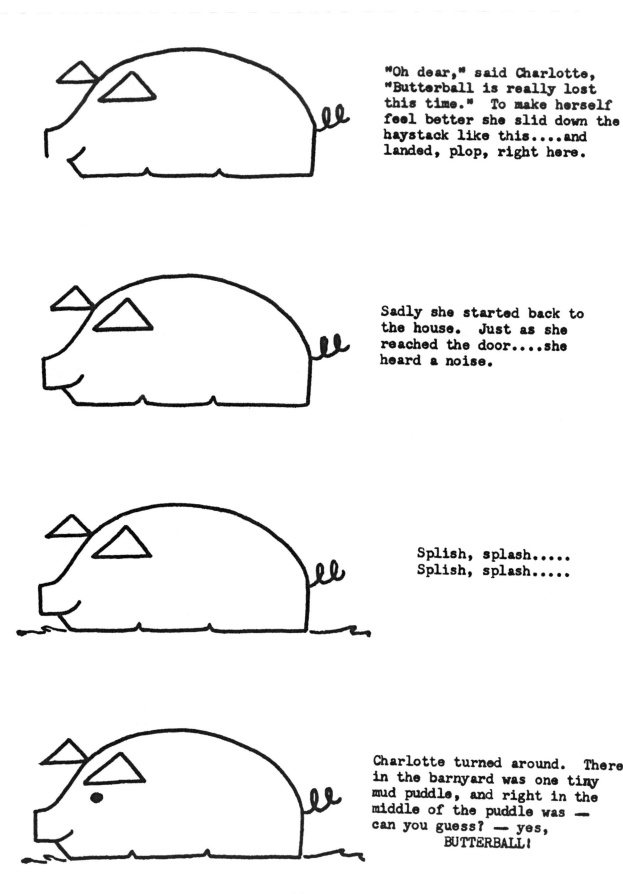

"Oh dear," said Charlotte,
"Butterball is really lost
this time." To make herself
feel better she slid down the
haystack like this....and
landed, plop, right here.

Sadly she started back to
the house. Just as she
reached the door....she
heard a noise.

Splish, splash.....
Splish, splash.....

Charlotte turned around. There
in the barnyard was one tiny
mud puddle, and right in the
middle of the puddle was —
can you guess? — yes,
 BUTTERBALL!

KRISTEN RAE'S FIRST CIRCUS

It was a perfect summer day, the special day that
Kristen Rae had thought would never come. But at
last she and her mother were inside the big tent.
Kristen has come to see her first circus.

This is the main ring where all
sorts of exciting things are
about to happen.

Kristen is sitting in a section
of seats over here. It's the
best spot to see everything.

Opposite is the bandstand. Crash!
Bang! The music begins to play.

The show starts with a parade.
The clowns tumble along like
this....playing tricks on their
way,

and here come elephants dancing
and horses prancing, like this.....

Now some performers begin to climb
to the top of the tent here....
and there.....

Ladders on each side take them higher
to a tightrope way up here.

Kristen holds her breath
as a man pedals across
on one wheel.

21

She is glad that there is a
safety net underneath.

Next, in a cage right here
an animal trainer performs
with snarling lions and
tigers,

and nearby two trained seals
balance balls on their noses.

Next the trapeze act begins,
and the stars of the circus
fly through the air, up and
over, like this.....

And now there is a tremendous
drum roll for the last exciting
act of the circus. Boom! A man
is shot from a cannon, and he
sails across the ring like this....
landing in a net over here.

What clapping and cheering, for it has
been a wonderful show! But of all the
exciting things that Kristen Rae saw on
that special day what she really liked
the best was this little clown monkey,
because he looked just like her favorite
stuffed toy that was waiting for her at
home.

A TRIP TO THE ZOO

One day a nice grandmother decided to take her five grand-
children to the zoo. Andrea, Nancy, Eileen, and Julie were
very excited, but David said, "I don't want to go with a
bunch of girls." So Grandma said, "Why don't you ask three
boys? That will make four boys and four girls, and eight is
the perfect number for me to take to the zoo. You will see
why later."

So David asked Rick and Bob and James to go along.
They all jumped into Grandma's van right here,

and they drove off to the zoo
like this.

First Grandma bought them each a
bag of peanuts. Then the girls
started off in this direction,

and the boys went the
opposite way.

24

The girls came to a big outside exhibit, "Animals of the African Plains." They looked over a moat here,

and the first thing they saw was a herd of zebra and several kinds of antelope.

Lions roamed the next section here.....A big daddy lion roared at them, so the girls ran on

to this last section which was
for giraffes and elephants.....
Those elephants really enjoyed
the peanuts that the girls gave
them.

When they left the African
animals, the girls took a
path which led down past the
tigers and up past the buffa-
loes like this....to a little
round building which was the
aviary. They went inside to
see the many beautiful birds
from all over the world.

Meanwhile, the boys had gone down
this path....to a building with a
domed roof. It was the reptile house.
The boys wanted to see the snakes and
crocodiles, so they went inside. It
was very hot there,

so before long they left and
took a path up here....and
across a bridge like this,

then down this way....
to another building with
a domed roof. This was
the "Polar Exhibit."
Inside it was very cold,
so after the boys saw
the polar bears and the
penguins,

they went outside and
started up this path that
leads to "Monkey Land."

They stopped to toss peanuts
to the monkeys....and to
watch the chimps do tricks....
and to see the baboons....
and last, to visit a big
gorilla who made faces at
them.

About that time the
girls left the aviary
and found Grandma
waiting beside a
pond here.

Three seals lived in
the pond. You can see
one of them swimming
here....and the other
two sunning themselves
on some rocks at the
side.

Now here come the boys,
and they're running....
because right next to
the seal pond they have
seen a big sign that says
"CAMEL RIDES," and under
the sign is this hand-
some camel with a howdah
on its back.

"Now it's time to go
home," said Grandma,
"but first I'm sure you
will want to take a camel
ride." Of course they
did, and you can see
the boys' heads here......

You can't see the girls, because
this howdah seats eight people,
and the girls are on the other
side of the camel's hump. And
now you know why Grandma said
eight kids were the perfect
number for a trip to the zoo.

THE PET SHOW

On Saturday the Elm Street kids decided to have a
pet show. They asked Mrs. Magill who owns the Sweet
Shop to be the judge. She said it was quite an honor
and whoever brought the winning pet would get a prize,
one of her famous garbage sundaes—that's three kinds
of icecream with everything on top.

The boys and girls agreed that this
playground at the end of Elm Street
was the perfect place for the show,
and they went home to get their pets.

Now it happened that every kid in the
neighborhood had either a cat or a dog,
everyone except a boy named Thai, who
was a new kid in town. He was, in fact,
new in the country. Thai didn't have a
pet of any kind, so he decided that he
would have to find one. There was a
grassy field next to the playground, so
he started off,

and before long he saw a rabbit. Thai
chased that rabbit, but it hopped here....
and there....and finally disappeared in
a patch of weeds.

Not discouraged, Thai wandered
on like this....until something
wriggling through the tall grass
caught his eye. A snake!

Try as he would Thai could
not catch the snake, which
slithered away into a hole
over here.

Thai kept walking until he
came to a small pond.

32

A turtle swimming here....
took one look and dived to
the bottom.

Then Thai saw something move
at the opposite side of the
pond, so he jumped across
like this....."Gotcha!" he
cried. Thai had found him-
self a pet.

Meanwhile, the other boys and
girls were bringing their pets
to the playground. Here comes
Shlomo, an Old English Sheep-
dog.....He is enormous, twice
as big as his owner in fact.

And here, nicely brushed and
combed, is Gretchen, a friendly
Collie mixture....and Tyke, a
peppy Wirehaired Terrier....and
Gus, a frisky Miniature Schnauzer
wearing a new red collar.

And now the cats: First here's
Monster, big and black, truly
the King of the Cats....and
Sunshine, a ladylike Persian
with a ribbon in her hair....
and last a pretty-kitty named
Calico.

At the playground Mrs. Magill
told the kids to line up with
their pets like this....so that
the judging could begin.

Then, "Wait for me," called
a voice, and along came Thai,
running so fast....that he
fell down smack-dab in front
of Mrs. Magill. And of course
his pet went flying right in
the midst of all the others.

Dogs and cats scattered in
all directions like this.....
The only animal left was Thai's
new pet. Here it is, the biggest
bullfrog you ever saw!

Of course that bullfrog didn't stick around
either. He hopped back to his pond. And
what about the garbage sundae? Well, nobody
won it, because not one pet was left in the
playground. Secretly Mrs. Magill was pleased
that she didn't have to choose between them.

So that ends the story of the liveliest pet show ever, as
well as the shortest. Later that day Mrs. Magill gave each
kid a free icecream cone, so everyone was happy, especially
Thai, because now he had a lot of new friends.

For a special vacation last year B. J. and Erin went
to Florida to visit their grandparents who lived in
a little square house near the ocean. Here it is.

Of course everyone wants to take souve-
nirs home from a vacation, but B. J. and
Erin had spent all of their allowance.
So one morning they started off down the
beach like this....looking for sea shells
along the way.

When they were a good distance
from the little square house, the
sky suddenly clouded over, and it
began to rain. They had to find
shelter, so they were happy to
see a pointed roof sticking up
behind a tremendous sand dune.

They scrambled over the sand dune
into a dilapidated old building
that was hardly more than a shack.

When their eyes became accustomed
to the darkness, they noticed a
paper tacked to a wall. It was
covered with spidery, old-fashioned
writing, and at the bottom was a
big X with knobby ends like this.

The writing began, "X marks the
spot where lies my treasure,"
and it was signed "Captain Crook."
B. J. ripped the paper from the
wall and read on: "First go up
and over." Turning Erin noticed
a ladder, so they climbed slowly
up....

through a hole in the ceiling,
and over like this....just the
way the directions had said,
until they reached a wall.

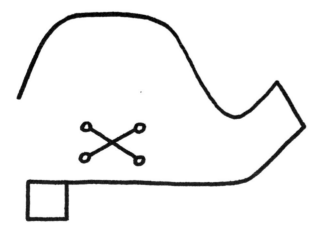

B. J. read on: "Press the
magic panel and proceed."
So Erin touched the wall here
and there, until suddenly a
door slid open, and they
crept down some dark steps
like this.

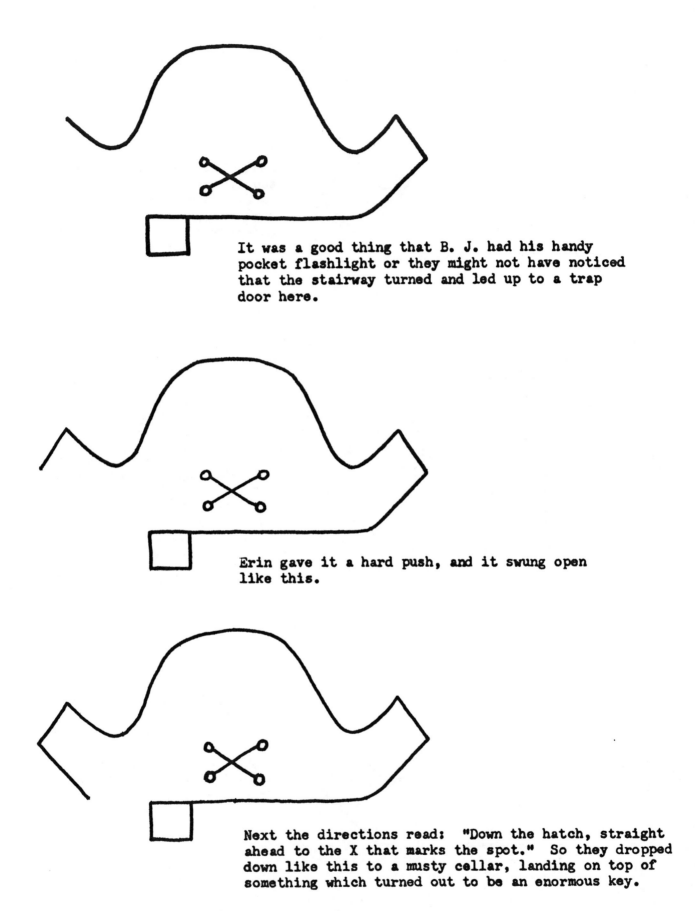

It was a good thing that B. J. had his handy
pocket flashlight or they might not have noticed
that the stairway turned and led up to a trap
door here.

Erin gave it a hard push, and it swung open
like this.

Next the directions read: "Down the hatch, straight
ahead to the X that marks the spot." So they dropped
down like this to a musty cellar, landing on top of
something which turned out to be an enormous key.

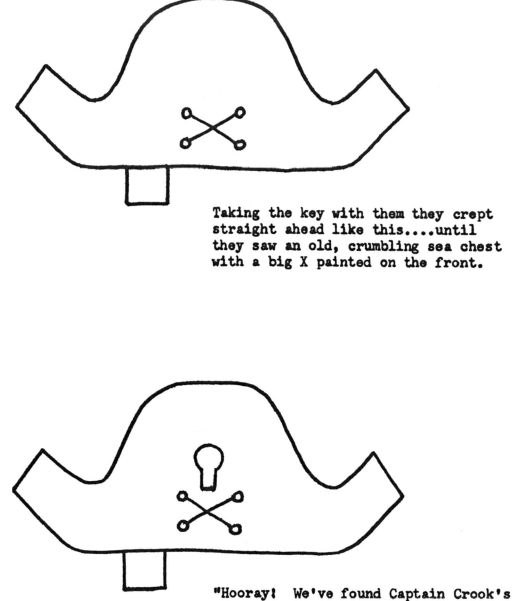

Taking the key with them they crept
straight ahead like this....until
they saw an old, crumbling sea chest
with a big X painted on the front.

"Hooray! We've found Captain Crook's
treasure, and this key will fit the
lock in that beat up old chest," cried
Erin pointing to a large keyhole above
the painted X.....Then they heard a
squeaking noise coming from inside the
chest. They were almost afraid to open
it, but they had come too far to turn
back now.

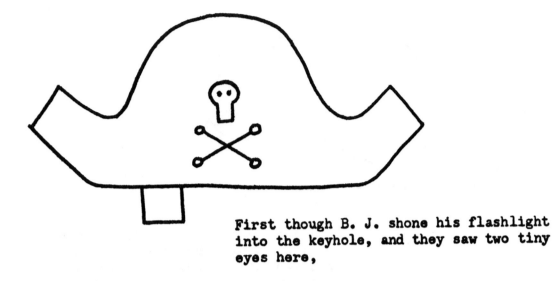

First though B. J. shone his flashlight
into the keyhole, and they saw two tiny
eyes here,

and a row of sharp teeth, in fact, mouse
teeth, here.....When at last they opened
the sea chest, the mouse jumped out and
ran away, and all that was left inside
was this old pirate's hat and eye patch.

If B. J. and Erin were a little disappointed
not to have found a real treasure, they had
to admit that they were bringing home a fine
souvenir from their Florida vacation.

Lindsay Ann lived in a house on the edge of town. Here it is.

Her cousin David Gavin, who was also her special friend, lived nearby. This is his house.

Both houses, being in the suburbs, had nice gardens like this....and that.....

Every summer for their vacation the cousins went to camp. As camps go it was a good one with all kinds of sports and crafts and nature trails that wound through the woods like this.....

41

But one year they decided that they would like to do something a bit different. A safari, a real hunting trip in Africa, would be just the thing! So they hopped in a plane and jetted off, zoom.....zoom.....zoom.....

Their trip was occasionally bumpy over the ocean.....
but at last they landed safely in Africa and started on their safari.

They had no sooner set off
through the tall waving grass
than they saw a big gray
shape appear from behind
a stand of trees.

Then something like a
garden hose raised up
like this.....It was
an elephant!

43

Before Lindsay could say, "Shoot," the elephant sprayed them with water and ran away.

"Well," said David, "a water hole must be near, and that would be a good place to find animals." So they tramped through the grass, and sure enough, soon they found this big pond.

44

Lindsay hid behind a big rock right here.....and David found himself a good hiding place under this clump of bushes.

Before long a head appeared on the far side of the water hole. The head had long sharp horns like this.....
It was an antelope. David tried his best to get a good shot, but he missed.
"Let me try next time," said Lindsay.

Then suddenly two long skinny necks appeared at the same place that the antelope had been. You can see them silhouetted here.

And the necks were topped with heads that had little horns and ears, and they looked this way.....and that.....Giraffes! Lindsay aimed carefully, but before she could shoot, the giraffes lowered their heads to drink and were seen no more.

A while later, again at the
far side of the water hole,
some zebras came to drink.
You can see their striped
coats here....and there....
at the edge of the pond.

"Rats!" said David. "We're
too far away from all the
animals. We might as well
go home." They had no sooner
started than right behind
them they heard a low growl,
and there was this enormous
lion quietly watching them.
He had just eaten lunch -
lucky for them - so he had
a smile on his face.

At last there was something near enough to shoot, so they did! Can you guess what they took home from their hunting trip? A stuffed lion? No! A lion skin rug? No again. I must tell you now that they weren't shooting with a gun. They were using a camera.....

and this is the picture they brought home to remember their safari in Africa.

LUKE MAGEE AND THE INDIANS

(The E. C. Noe Sheriff)

Once upon a time out in the wild west
there was a cowboy by the name of Luke
Magee. Here's an L for Luke and an
M for Magee.

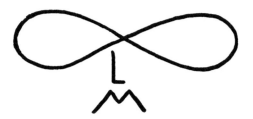

There was nothing that Luke liked
better than to take a ride on his
horse, and while he rode he would
practice his roping. He was so
good at roping that he could twirl
his lasso around in a perfect fig-
ure 8 like this.

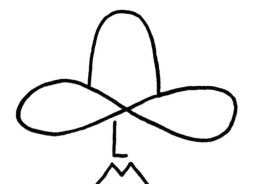

Sometimes he would ride over a
hill like this,

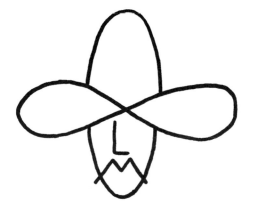

and other times he would ride
down into a gully like this.

49

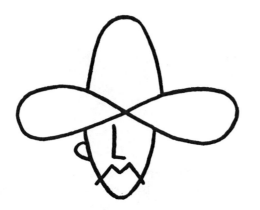

One day while Luke Magee was out a-ridin' and a-ropin', two little Indians were playing at the edge of the gully. The first one was over here,

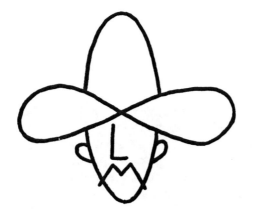

and the second one was over there.

When they heard hoofbeats in the distance, the first Indian ran and hid behind this rock,

and the second one ran and hid behind that rock.

50

Along came Luke Magee on his
horse like this.

"Whoa!" yelled Luke, and he stopped
his horse between the two rocks.
He looked hard at this one,

and he looked even harder at the
other one.

"Who's there?" shouted Luke.
"We're Indians," said the first
little Indian, and he poked his
nose from behind his rock like this.

51

"You'd better leave our hunt-
ing ground or we'll shoot you
with our bows and arrows," said
the second one, and he poked
his nose from behind his rock
like this.

"I don't believe you're really
Indians," said Luke Magee. "Oh
yes we are," said the first one.
"And here are my feathers to prove
it." And his feathers came up
from behind the rock like this.

"And here are my feathers to
prove it too. Now do you give
up?" And the second one's
feathers came up from behind
his rock.

"You win. I sure do give up," said Luke. "Can't you see my hands are in the air?" So off he rode, and he gave his lasso a nice little twirl like this, a perfect figure 8, of course.

He had a great big smile on his face like this,

because he knew that they were two little Indians who had borrowed their grandfathers' war bonnets to play in that day, but they didn't know that he was the sheriff. And here's his star to prove it.

A MONSTER TALE

There once were some twins named Jennifer and Michael. Even though one was a girl and the other a boy, everyone said that they were alike as two peas in a pod. Here they are.

They didn't live in a pod, of course, but in a house. Jennifer's bedroom was upstairs under this gable,

and Michael's was over here under that gable.

In between there was a dark space under the sloping roof which was a perfect place for telling scary stories.

They had been there one afternoon telling each other tales about monsters (the more frightening the better) when their mother called them down to supper. They were so hungry that they didn't bother using the stairs. Jennifer slid down the bannister like this,

and Michael slid down like that.

Their mother was very angry, because she had told them ninety-nine times never to slide down the bannister. So instead of fried chicken and strawberry shortcake, she gave them porridge to eat and sent them back upstairs.

They were so sad (and mad) that they decided to run away from home. First they went to Jennifer's room, but there was no way to escape from her window.

55

so they crossed the attic to
Michael's room,

and they slid down a drainpipe
into the dark night.

They could see a full moon
coming up behind a hill
like this.

"Let's be careful," whispered
Michael. "Werewolves come
out when there's a full moon."
They began to tiptoe up the
hill.

Suddenly there was a terrible
flash of lightning like this.....
"That's what happened when
Frankenstein's monster came
to life," screamed Jennifer.

They ran over the hill, and
just as they started down, a
bat flitted by right over their
heads....."That's Dracula!"
yelled Michael.

By now they wanted to go home,
but they were lost and had
circled like this....into a
dark woods which was just the
kind of place that a person
could expect to meet Bigfoot.

It was just by luck that they
jumped over a little stream
and found themselves on the
road that led to their house.
They started down it, lickety-
split, like this.

Right here Jennifer slipped
and fell, but she picked
herself up and ran on.

Then Michael slipped and
fell, but he too got up and
ran on.

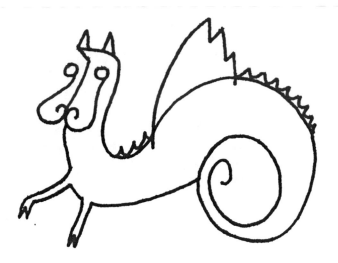

By now they could see
their own house. They
raced up the front walk,

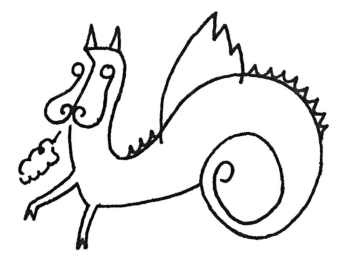

kicking up a big cloud
of dust as they ran,

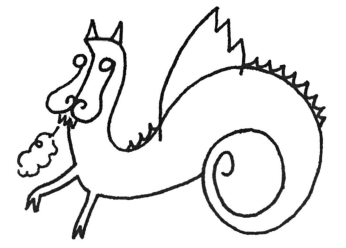

and stumbled over the porch
steps into their house. "Home
safe!" cried Jennifer. "I
guess there weren't any mon-
sters outside after all."
But she was wrong. They
just didn't notice the mon-
ster on their own doorstep,
a GOOD OLD-FASHIONED DRAGON!
And here he is.

When they built the planetarium on High Street, Tommy's father said it looked as if a giant had turned over his cereal bowl.

Since it was standing in the middle of a neat round park, Tommy's mother said it looked more like a hat with a green brim that she had seen in Macy's window.

Tommy didn't care what it looked like. Next to baseball sky watching was his favorite thing, and he knew that a planetarium was the best place to learn about stars and planets. His grandfather had already shown him how to find the North Star and the Dippers, and he wanted to learn more. He was glad he lived in this house right across the street.

His friends, Marc and Sara, also lived on
High Street in a house here.....Like Tommy
they wanted to learn more about what went
on in the sky.

So on the night that the planetarium opened,
Tommy, Marc, and Sara were the first ones
inside. They are sitting together here.

Soon the other seats were filled.....
The lights went off, and the show began.

First some strange, rough mountains
appeared.

Then a bright ball seemed to rise from
behind the mountains.....No, it wasn't
the moon. It was the earth as it appears
from the landscape of the moon.

Next the dome of the planetarium was sprinkled
with tiny, sparkling lights. To Tommy and his
friends they looked just like this.....They
couldn't tell one from another.

It helped when a bright arrow pointed here....and here....
and there.....

The program lasted almost an hour, and it was dark
outside when the audience left. The kids looked up
at the sky hoping to see some familiar stars, but all
they could see is a big round moon.

"The moon is too bright," said Tommy. "We won't be able
to see many stars. But I can sure see the face on the
moon." He was right. The face was much clearer than
usual.

"I guess there's nothing special to see," he said, "so
we might as well go home." Tommy crossed the street to
his house,

and Marc and Sara crossed the street to their house.

Too bad! If they had waited one minute more, this is what
they would have seen.....I know what this strange creature
is thinking. "What a way to greet a visitor from outer
space!"

There once was a tiny fairy queen
who lived in a little cloud over
my garden.

She was a magic creature
who could speak to every-
thing in nature. One day
she flew down very close
to the ground. Everyone
knows that fairies are
invisible, but you can
see her wings.

"Wake up, you lazy earthworms,"
she called. "You've been sleep-
ing all winter, and it's time for
you to stir up this garden." A
little worm over here heard her
and started along like this.

And his brother came
from the other side
like that.

They met in the middle and
poked their pointy heads up
from the ground like this....
and that.....

"Hello, my friends," said
the fairy queen. "You've
done well." The earth-
worms wiggled their heads
in greeting and disappeared
leaving a little hole right
here.

The fairy queen flew back to
her cloud and sent a shining
raindrop down.

69

The raindrop fell into
the little hole that the
earthworms had made, and
soon something began to
grow....up....and up....
like this.

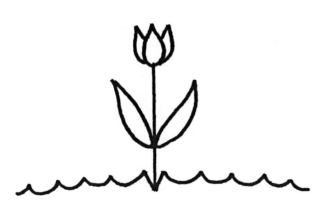

Then, like magic, it opened
like this....and like that....
to make a tulip. The fairy
queen was pleased, because
that tulip meant that it was
really spring.

A PICNIC IN THE PARK

(Summer)

One summer morning when Christopher woke up, the sun was
shining so brightly and the sky was so blue that he knew
it was a day to do something special and that the "something
special" should be done outside. It would be fun to have
company, he thought, so he asked Elizabeth and Eric to go
to the park with him. Christopher and Elizabeth brought
a picnic lunch, and Eric brought his model sailboat, and
they set off.

When they came to the park, they
took this path that lead to their
favorite place.

They put the picnic basket here

next to a long bench where they
sat down to take off their shoes
and socks.

71

Beside the bench was a
shallow pool for sailing
small boats and wading.

Taking Eric's boat with
them, they walked around
like this....to some steps
at the edge of the pool,
and they waded into the
water.

Here they are, Christopher....
and Elizabeth....and Eric.

The breeze was just right
on that summer day. It
caught the sails, and the
boat flew across the water
like this.

Then they slowly pulled it
back with a string attached
to the stern.

The boat sailed to and fro
like this....for quite a long
time until their stomachs
told them it was time to eat.

There was a grassy spot
here....planted with flowers,
bushes, and trees around
the edge. What a fine spot
for a picnic!

So they unpacked their lunch
here.....Tuna fish sandwiches,
apples, and chocolate milk
never tasted better. When
they were done, did they throw
their paper cups and sandwich
bags into the bushes? Of course
not! They put everything back
into the basket, so that the
park would be nice for other
people.

Then they put on their socks
and shoes and started home
like this.....The park was
the same as they found it,
except for this beautiful
butterfly that had joined
them on their picnic.

A WALK IN THE WOODS

(Fall)

It was a bright fall afternoon,
a perfect day to take a walk in
fact. Kate whistled for her dog,
Ginger, and they started off.

At the end of the street there
was a woods, and a path ran
through the woods like this.....
Kate started down the path,
looking this way and that.

There were many things to see.
To the left stood a maple tree
with leaves of brilliant, flaming
red.

And over here to the right
was a beech with leaves of
gold.

Next Kate saw a tree loaded with
green tennis balls. "Walnuts!"
said Kate. "Next week I'll bring
a bag and take some home."

Then, plop! Over here a
hickory nut fell from
its tree.

A bushy-tailed squirrel
pounced on the nut and
scampered across the path
to bury it here.

Finally to the right Kate saw the
giant oak that marked the far side
of the woods. It was time to turn
around and head for home.

And what was Ginger doing all this time?
While Kate kept to the path, Ginger raced
back and forth like this....chasing
squirrels and chipmunks.

When he reached the giant oak Ginger
too turned back, dashing in and out
through the woods until he met Kate
at the street that led home.

And what did Kate bring home from her walk in
the woods? Just this one perfect leaf that had
fallen from the giant oak tree.

THE FIRST SNOW

(Winter)

One morning Kim looked out of the window and saw the first snow of winter. After waking the twins, Chris and Mark, Kim went to look for the sled. Here it is...., a nice long one as you can see.

Breakfast over, they bundled into snow-suits, caps, scarves, mittens, and boots. Here they are piled together on the sled rather like a lumpy bag of laundry.

Down a hill they coasted stopping at the edge of the school playground, and they jumped off the sled, one...., two...., three.....

Brandon, Brian, and Terri were already at the playground. Since the snow was fresh they decided to lay out a game of fox and geese. They stamped out a big circle like an enormous wheel.

Then they made a little circle in the middle.....That was "home," the safe place in this winter game of tag.

Brandon was the first fox, and soon he caught Brian who became the second fox. They ran and ran catching one another and falling down, but no one could catch Terri, so she won the game. By then the snow was really messy, and they couldn't see the lines, so they decided to have a snowball fight instead. Kim, Chris, and Mark built a little round fort up here beside their sled,

and they began to make snowballs which they lined up like this.....

Meanwhile Brandon, Brian,
and Terri were building
a big fort down here.

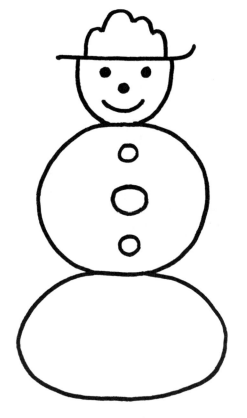

The battle began, and fast
and furious it was. Of
course not every snowball
flew far enough. Some fell
short and landed here....
and there.....

I guess you know that nothing
makes a person hungrier than
playing in the snow does, so
they all went home for lunch.
Brandon and Brian and Terri
went off this way to their
houses....here....and here....
and there....,

and Kim and the twins pulled
their big sled up the hill
like this.....As they trudged
along Kim said, "I think that
we should build a snowman
this afternoon." And I know
they did, because here he is.

A PUSSY CAT

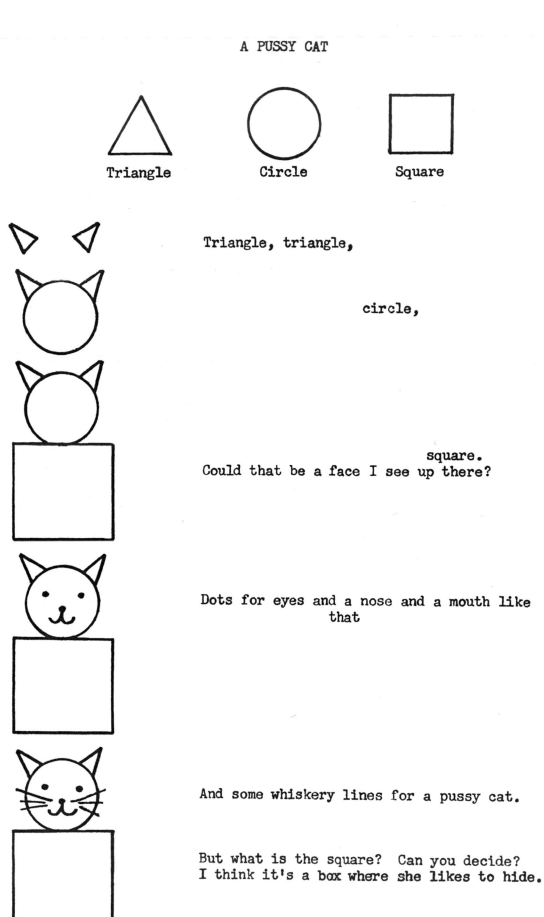

Triangle Circle Square

Triangle, triangle,

circle,

square.
Could that be a face I see up there?

Dots for eyes and a nose and a mouth like
that

And some whiskery lines for a pussy cat.

But what is the square? Can you decide?
I think it's a box where she likes to hide.

A PUPPY DOG

Circle Oval Triangle Rectangle

I'll start with a circle just
like this,

Add ovals
here....

....and there,

An upside down triangle right
in the middle,....
Above it two circles, filled
in and little,

Some dips right here. Is it
still a riddle?

Of course not. It's a puppy dog.
I'll add his tongue with care.

And some dotty speckles
That look like freckles,

And what should our puppy wear?

A long skinny rectangle. What
could it be?
He's wearing a flea collar.
Can't you see?

FRED THE DINOSAUR

Oval Rectangle Triangle

First let's draw an oval
 that looks just like an egg.

Then add four small rectangles.
Each one is a leg.

Now for a tail a triangle.
Let it drag a speck.

Up here a larger rectangle
 will make a sturdy neck.

On top of it an oval
 will be his tiny head.

A line for a mouth, a dot for
 an eye —
 It's our dinosaur named
 FRED!

THE HOUSES ON MY STREET

Triangle Square Rectangle

Using just three shapes I'll show you how
To draw a picture. Let's start now.

Begin with a triangle. Put it there,

And down below it add a square.

Next draw a rectangle low and wide
Lying on its longer side,

And on the top attached like that
Put another one that's low and flat.

Here make a rectangle standing tall

Topped by a triangle....(draw it small),

And on the side as if stuck like glue
Add another rectangle....

....make that two.

Although this picture's not complete,
It looks like houses on my street.

But a house needs a chimney and a door,
So give each two small rectangles more.

For windows tiny squares are fun,
So draw in lots, and now you're done.

Oh, you want some bushes and grass? If
 you choose,
That's easy! Just add some curlicues.

SKY SHAPES

| Circle | Semicircle | Crescent | Star |

This shape is round, a circle.
 Have you seen one in the sky?
Yes! It's the sun, a burning ball
 So bright it hurts your eye.

And here's another sky shape
 That's round but not so bright,
A full moon shining in the dark
 That you can see at night.

91

Sometimes there is a half-moon
Like this semicircle here,

And other times a crescent
When the new moon does appear.

And next we have a star shape
Which you know very well.
Do twinkling stars look just like this?
They're too far away to tell.

And last we can't forget the clouds
With shapes I cannot name,
Like whipped cream or like cotton puffs,
And no two are the same.

THE LITTLE DRAGON-MONSTER

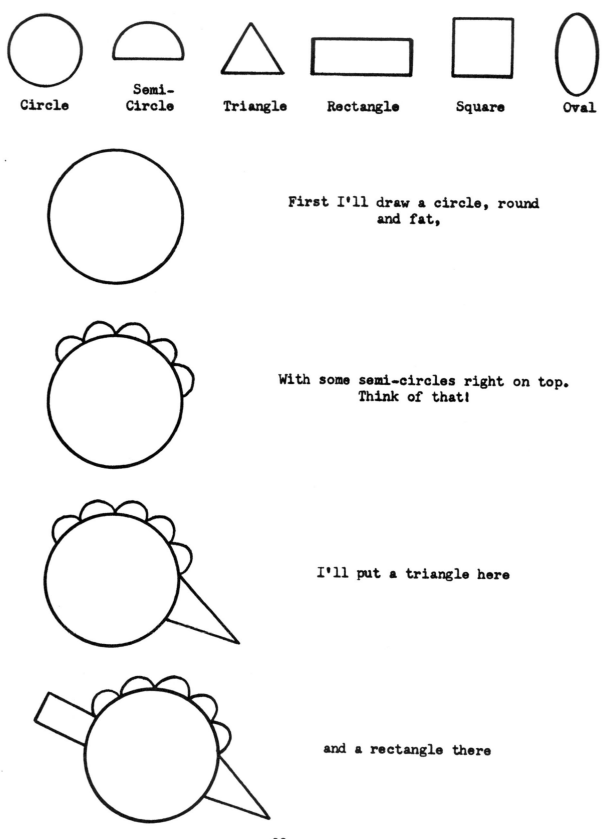

Circle Semi-Circle Triangle Rectangle Square Oval

First I'll draw a circle, round and fat,

With some semi-circles right on top. Think of that!

I'll put a triangle here

and a rectangle there

93

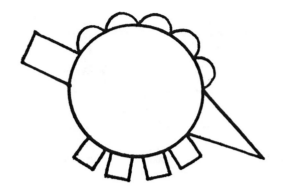

And a square
 and a square
 and a square
 and a square.

Next I'll draw an oval,
 narrow and thin,

With two lines on top for horns
 and one for a grin.

Last a dot for an eye. "Well,
 how do you do?"
Says this little dragon-monster
 I've drawn for you.

A VALENTINE

For a picture of love draw a happy
heart-shaped face

With a smiling mouth like this....
and eyes that shine.

Then all you need to add is a bit
of lace

And some kisses here to make a
valentine.

DANNY THE LEPRECHAUN

(for St. Patrick's Day)

Here's a funny story I once heard told
Of Danny the Leprechaun who lost his pot of gold.
He cried, "Where did I hide it? What will I do?

If I never find it, my heart

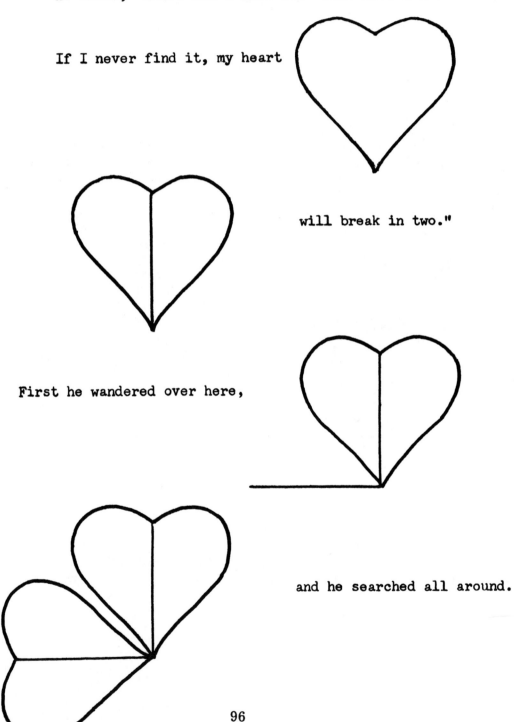

will break in two."

First he wandered over here,

and he searched all around.

96

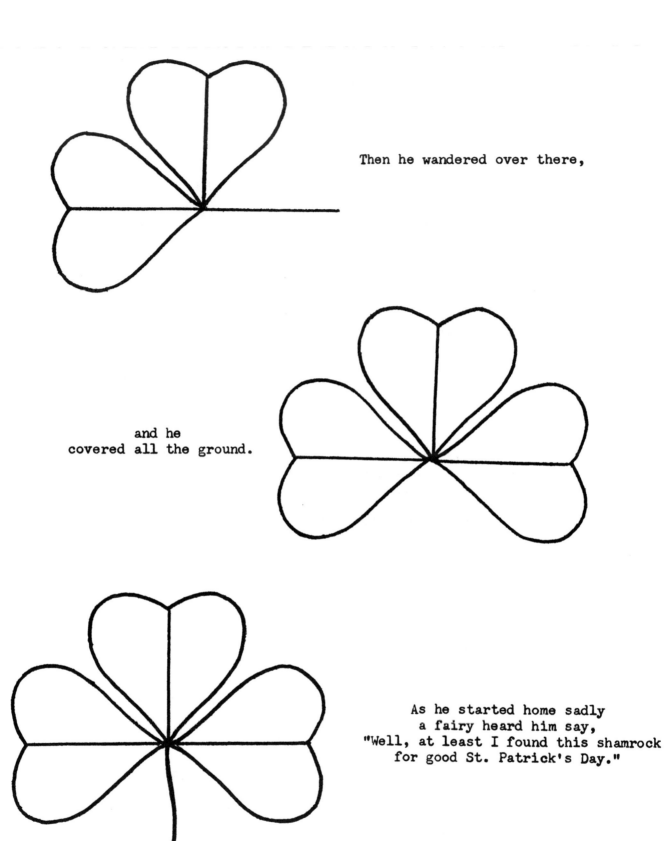

Then he wandered over there,

and he
covered all the ground.

As he started home sadly
a fairy heard him say,
"Well, at least I found this shamrock
for good St. Patrick's Day."

MAMA'S EGG

(for Easter)

One Monday in the early spring
Guess what Mama found,
A giant egg that looked like this
Just lying on the ground.

On Tuesday when she looked outside
That egg had changed somewhat.
A tiny wad of fluffy fur
Was growing from this spot.

On Wednesday there was something new,
A long and shapely ear.

On Thursday yet another one
Had sprouted very near.

98

On Friday little eyes appeared.

The nose was also new.

On Saturday a mouth was there

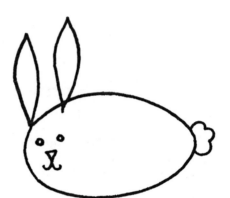

And silky whiskers grew.

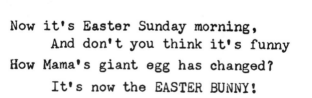

Now it's Easter Sunday morning,
 And don't you think it's funny
How Mama's giant egg has changed?
 It's now the EASTER BUNNY!

HAPPY BIRTHDAY, USA!

(for July 4th)

Happy birthday, USA!
I will bake a cake today.

I'll put it on a special
plate
So that we can celebrate.

This plate will have a
pedestal
That's shaped just like
the Liberty Bell

With bunting loops along
the rim

And one big star right here
for trim.

One giant candle here, and
quick,

101

Let's strike a match and light the wick.

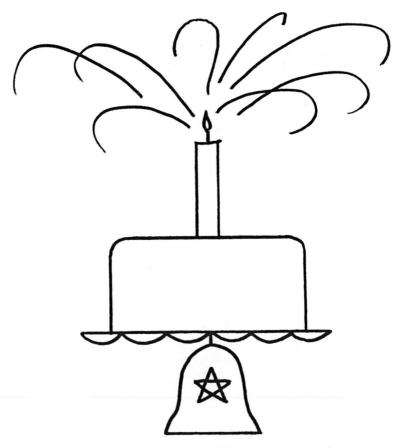

"BANG!" go the fireworks into the sky
On this special birthday, the Fourth of July.

102

CHRISTOPHER COLUMBUS

(for Columbus Day)

Christopher Columbus sailed west one day
from Spain.

He hoped to find the Indies across the
bounding main.

Columbus had three little ships. I'll
draw them now for you.....

The ships had sails a bit like this....

....and masts and rigging too.

At last with Spanish flags raised high....

....they came to land one day.
East Indies? No, America was standing
in the way.

Columbus didn't know that back in

1492

But I know and I'll remember on
October 12, won't you?

TRICK OR TREAT

(for HALLOWEEN)

Two little ghosts passed down the street,

Stopped at this house for trick or treat,

Then walked on to another door,

Got candy, and went on for more.

They turned around and started back,

And stopped again to fill their sack.

They went to one last house right here,

Then hurried on, for home was near.

They hadn't noticed in the sky
That witches' hats were blowing by

Or seen the moon so round and bright
That shone above to light the night.

But most of all they hadn't seen
This pumpkin face for Halloween.
A stem right here, and then he's done!
(A jack-o'-lantern's lots of fun.)

TOM TURKEY

(for Thanksgiving)

First put your hand down
fingers spread wide.
Draw carefully around it,
just outside.

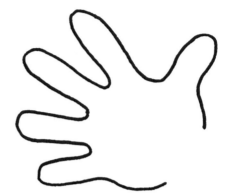

Make loops between the fingers
here and here and here.

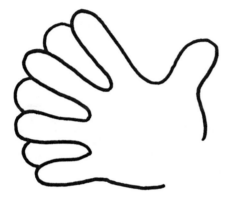

Then connect these lines and add
a shape like a tear.

Make a big fat V for a
wing to fly,

And a pointy beak

and a little round eye.

Add a bristly beard

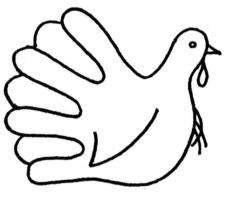

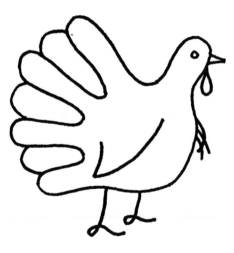

and two squiggly feet,
And you have TOM TURKEY, your Thanksgiving
treat!

(Drawing around the hand to make a turkey is an old trick. Children
at your story hour will enjoy doing it as a related craft.)

MY DREIDEL

(for Hanukkah)

My dreidel is a special top,

 But it isn't round, it's square.

It has a little knob up here....

And a little point down there.

It's time for games at Hanukkah.

Watch me while I spin.

'Round and 'round my dreidel goes,

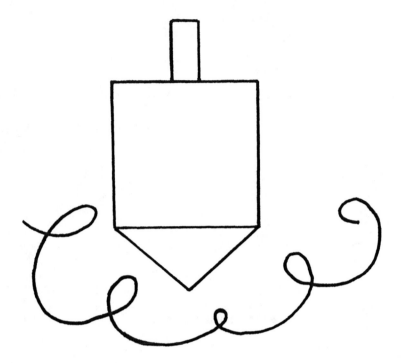

It's gimmel.... and I win!

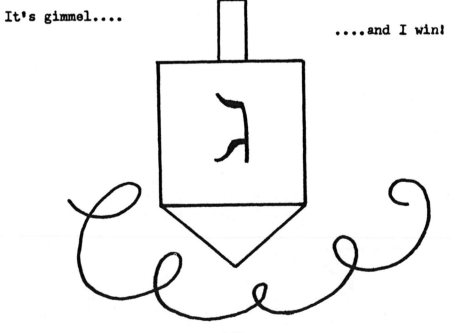

110

GETTING READY FOR CHRISTMAS

My cards are sent; my shopping's done, for Christmas day is near,
And now it's time to trim the house, the best job of the year.

First, I have a holly wreath. Let's hang it on the door,

And here's a Christmas tree so tall we'll stand it
on the floor.

Next we'll drag the Yule log in. It seems
to weigh a ton,
But for our fire on Christmas, we must have
the biggest one.

And here's a partridge. It's a favorite ornament
of mine.
Since we don't have a pear tree, I will hang it
on the pine.

111

And now another special bird,....see,
it's a snow white dove.
I'll add it to the Christmas tree,
a sign of peace and love.

An angel with a halo next, with wings
spread out to fly,

And here's the silver platter that will
hold our Christmas pie.

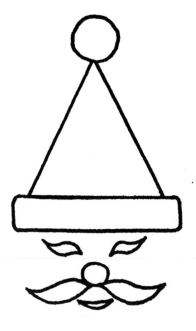

It's time to hang the stockings,
 one here......,
 the other there......,
Now the house is set for Christmas,
 and we have trimmed with care.

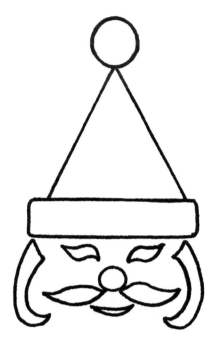

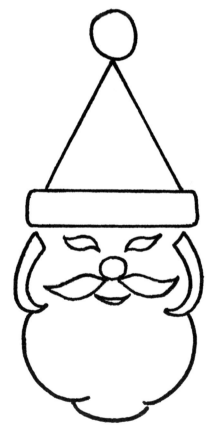

Outside the snow is falling,
 and I'm glad we're done,
 because
In these fluffy drifts I see someone.
 Yes, here comes
 SANTA CLAUS!